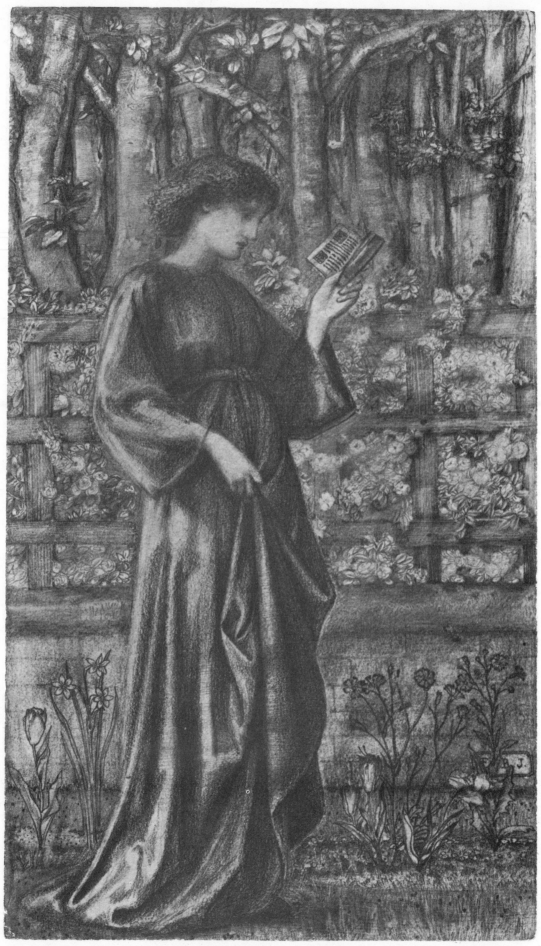

Scene from *St. George and the Dragon* (see page 4): The Princess of Egypt reading a missal in her garden.

PRE-RAPHAELITE
DRAWINGS BY
BURNE-JONES

46 Illustrations by

Sir Edward Coley Burne-Jones

Dover Publications, Inc.
New York

PUBLISHER'S NOTE

Sir Edward Coley Burne-Jones (1833–1898; knighted 1894) was the chief English Pre-Raphaelite painter in the second generation of the art movement that had been formed in 1848 by Dante Gabriel Rossetti, John Everett Millais and William Holman Hunt. Like those masters, Burne-Jones was greatly influenced by medieval art and by the work of fifteenth-century Italian artists, especially Botticelli. His subject matter, in addition to the Arthurian legends of his ancestral Wales, included Greek and Roman mythology, the Old and New Testaments, early Christian legend and medieval romance. The men and women who people those scenes are characterized by a piquant contrast between their invariable look of fixed melancholy and their superb physical condition and eugenic fitness.

Burne-Jones's deep interest in the decorative arts is also reflected in the present volume, which includes designs for tapestry, stained glass and a bronze relief, as well as painted piano lids.

Although brilliant color is an integral feature of Pre-Raphaelite art, careful and strong drawing gave a solid framework to Burne-Jones's painting, and his highly finished and elaborate studies in pencil, chalk and other media led one contemporary critic "to believe that draughtsmanship, composition, sense of proportion in values, outweigh in decorative value the most beautiful of colour schemes."

All the works in this volume are reproduced directly from original platinum prints made by Frederick Hollyer of London, who specialized in the photographing of art works and sold his reproductions commercially. At the time, his prints were very economically priced, and helped to disseminate British art in British homes. Today, when their sales value has increased enormously, they sometimes preserve a record of works of art of which no other trace remains.

The dating of Burne-Jones drawings is difficult because he habitually developed his projects in a desultory fashion over years and even decades. The dates given here generally refer to the earliest recorded instance of the artist's involvement with the project in question.

Copyright © 1981 by Dover Publications, Inc.
All rights reserved under Pan American and International Copyright Conventions.

Published in Canada by General Publishing Company, Ltd., 30 Lesmill Road, Don Mills, Toronto, Ontario.
Published in the United Kingdom by Constable and Company, Ltd., 10 Orange Street, London WC2H 7EG.

Pre-Raphaelite Drawings by Burne-Jones, first published by Dover Publications, Inc., in 1981, is a new selection of drawings reproduced directly from the platinum prints made by the London photographer Frederick Hollyer at the end of the nineteenth century (see Note above). The publisher is grateful to Mr. Scott Elliott for suggesting the volume and lending the rare original photographs for reproduction.

International Standard Book Number: 0-486-24113-0
Library of Congress Catalog Card Number: 80-69639

Manufactured in the United States of America
Dover Publications, Inc.
180 Varick Street
New York, N.Y. 10014

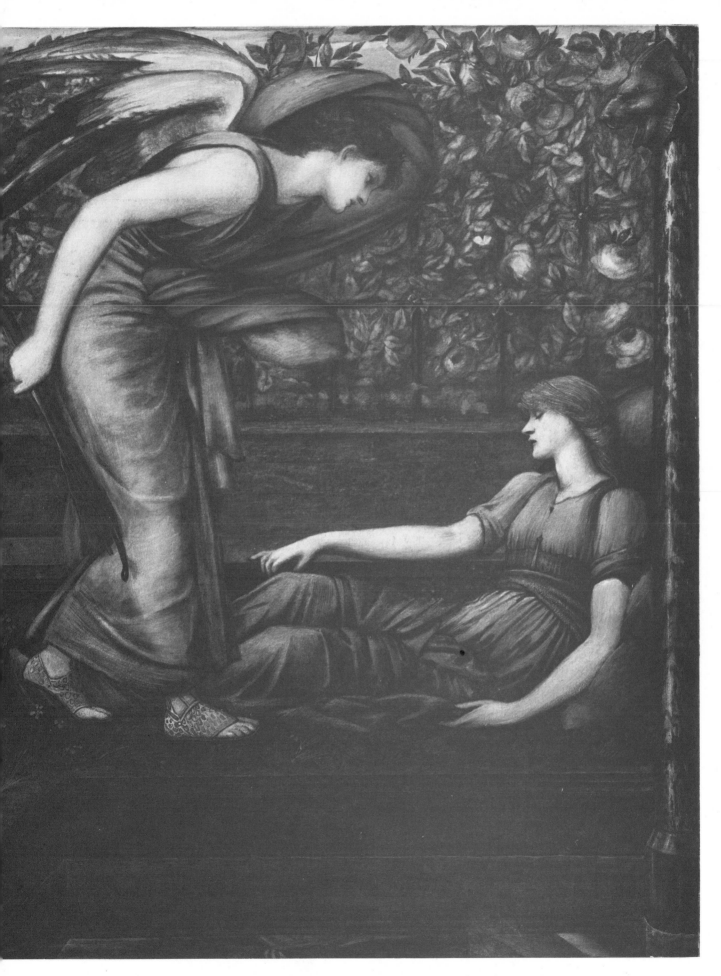

Cupid and Psyche. Watercolor, 1865. Cupid finds Psyche asleep at the
fountain in the garden.

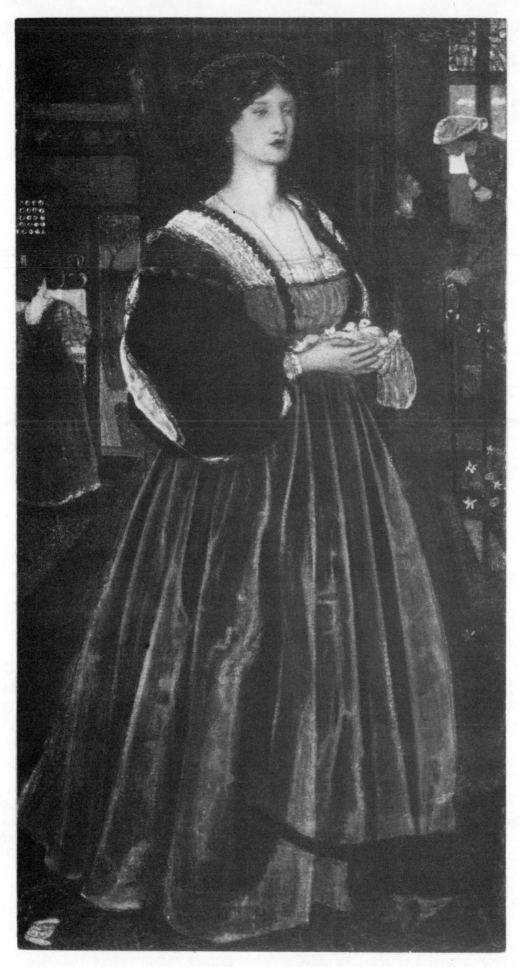

Clara von Bork. Watercolor, 1865. A character from the 1847 novel *Sidonia the Sorceress* by Wilhelm Meinhold.

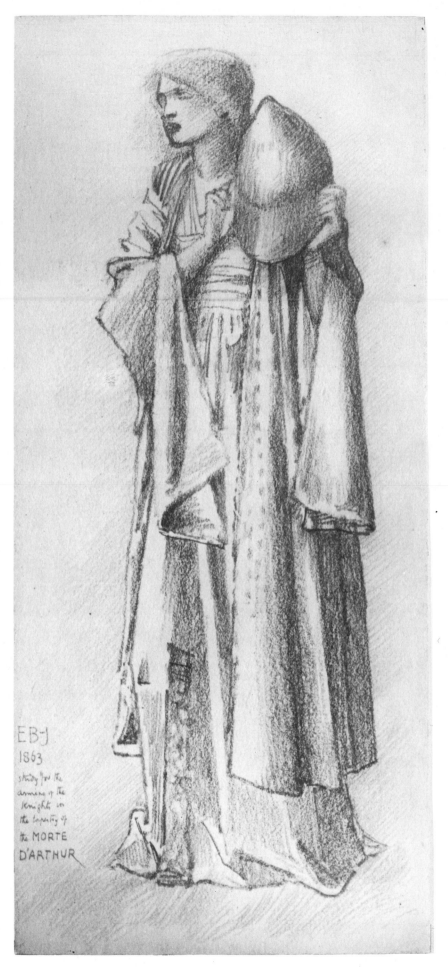

EBJ
1863
study for the
arming of the
knights in
the tapestry of
the MORTE
D'ARTHUR

Study for the arming of the knights in the tapestry of the *Morte d'Arthur*.
1863.

3

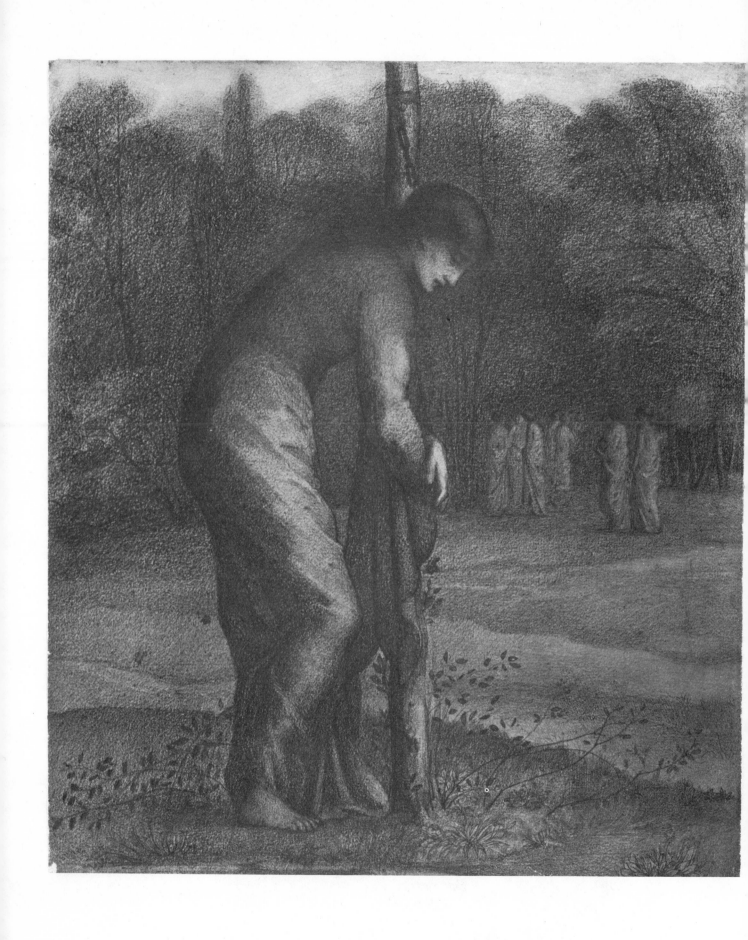

Scene from the seven-part series *St. George and the Dragon* of 1865/6 (studies
for the oils in the dining room at Witley): The Princess chained to the tree as a
sacrifice to the dragon.

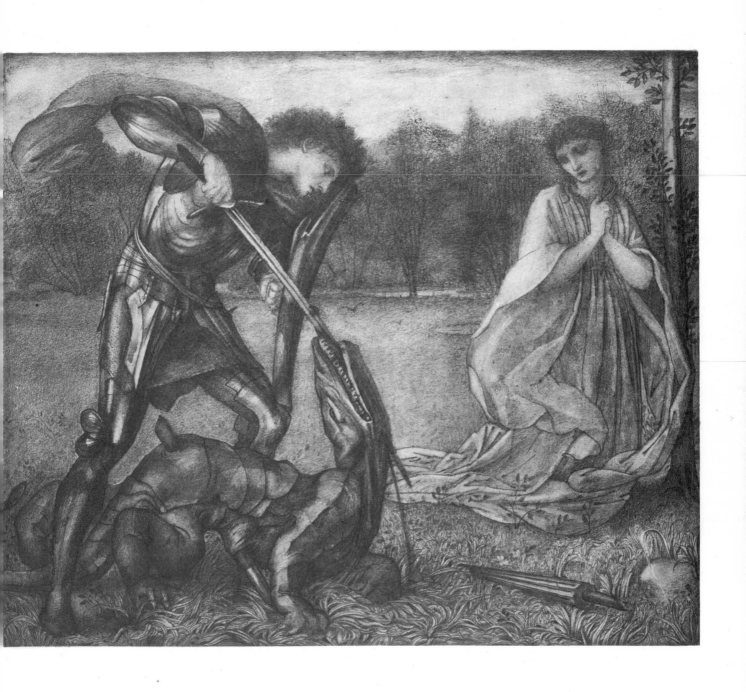

Scene from *St. George and the Dragon:* The Saint slaying the monster.

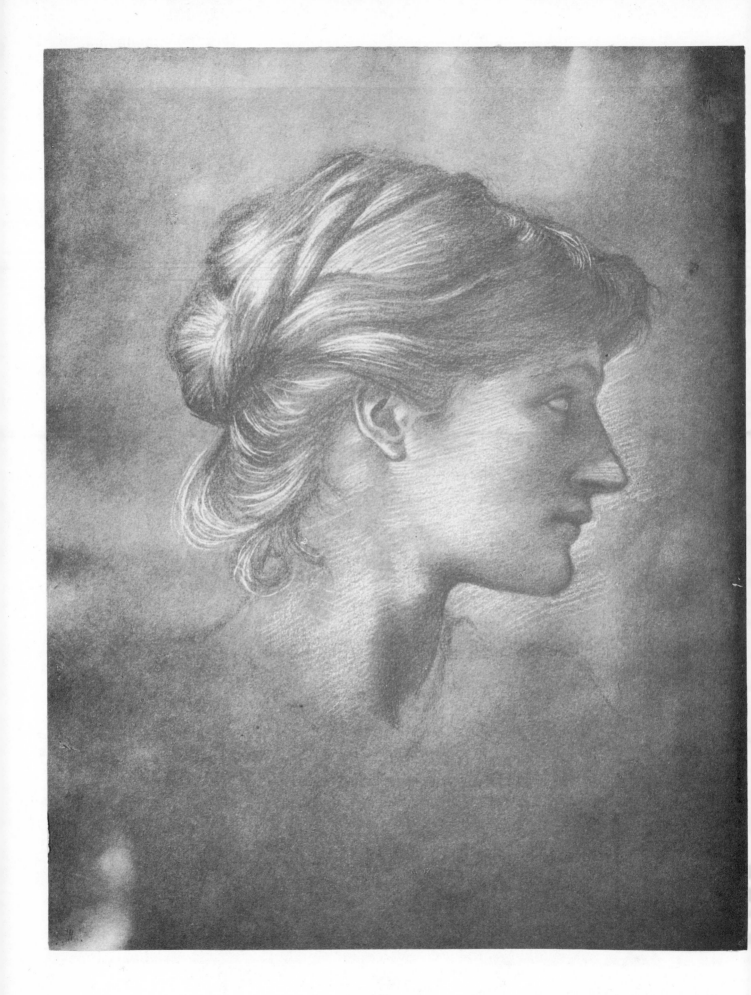

6 Study for the head of Danae in the oil *Danae and the Brazen Tower.* 1872.

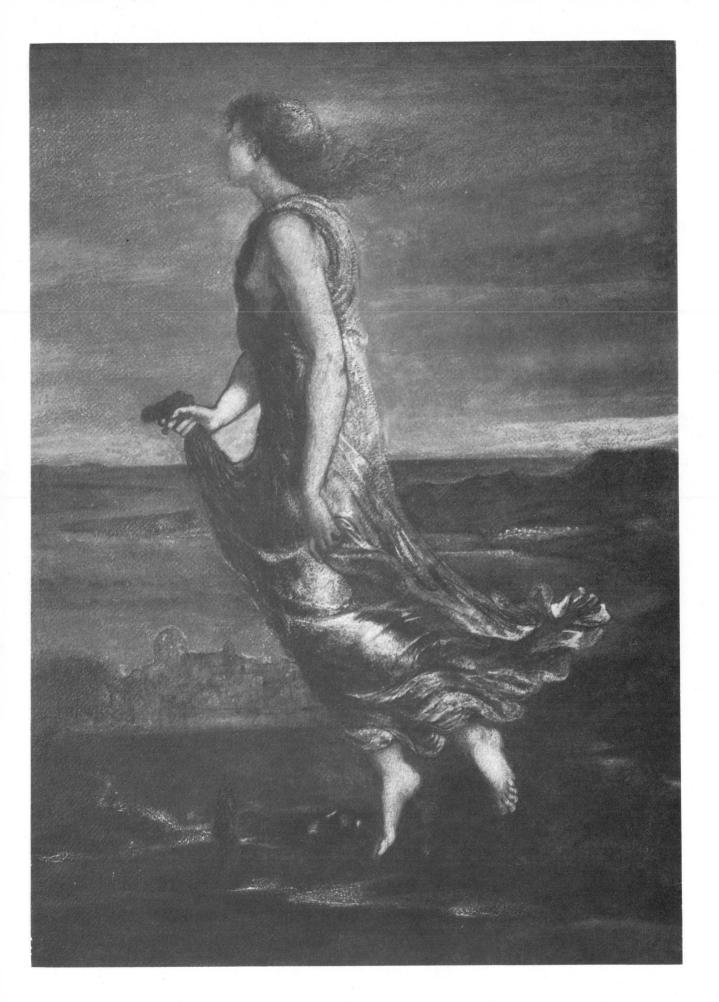

Evening Star. 1870.

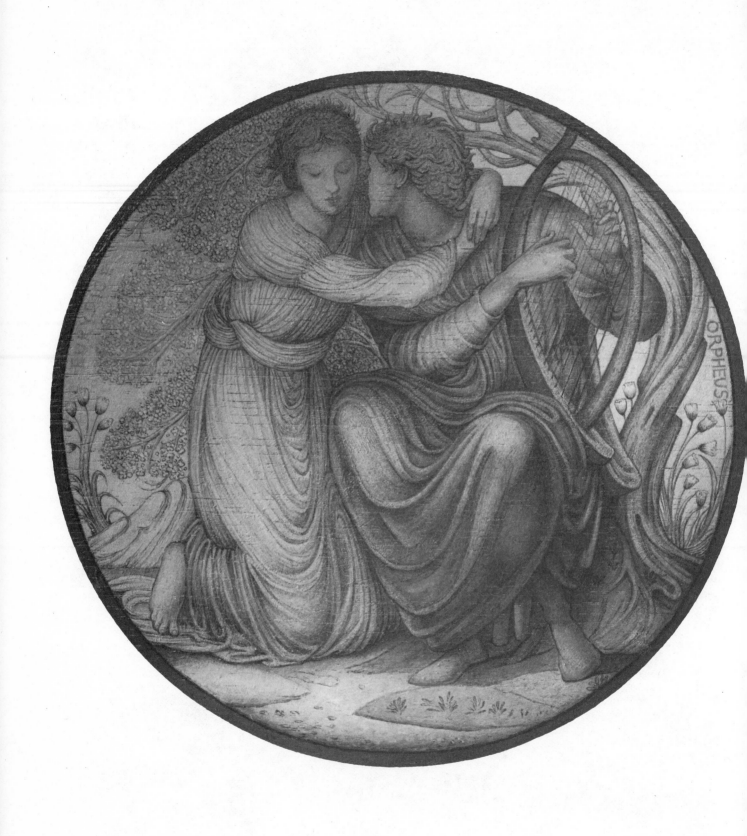

First scene from the eleven-part *Orpheus* of 1872/3: The Garden.

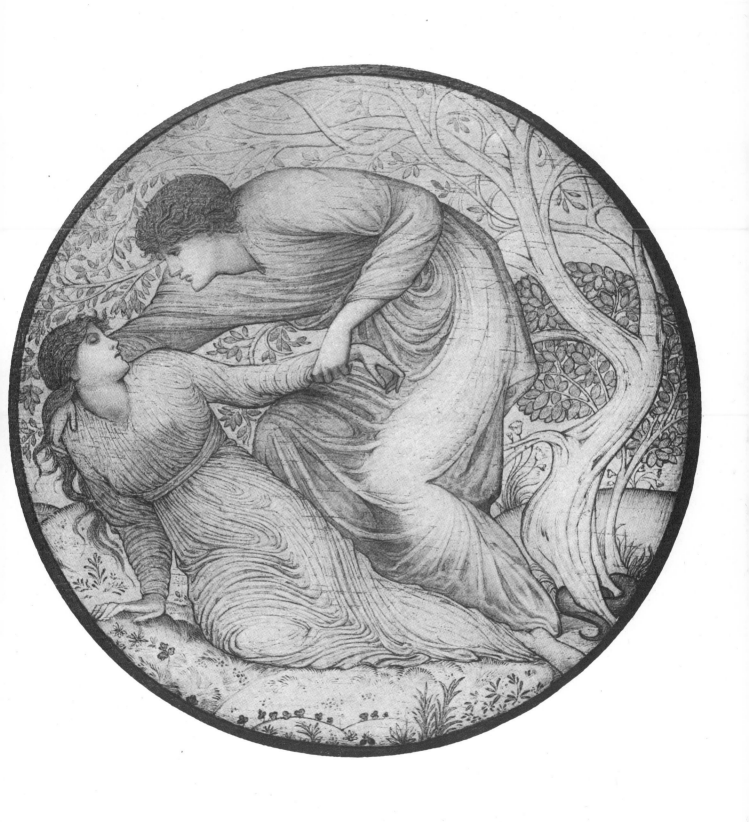

Orpheus: The Garden Poisoned. (Eurydice has been bitten by a snake.) 9

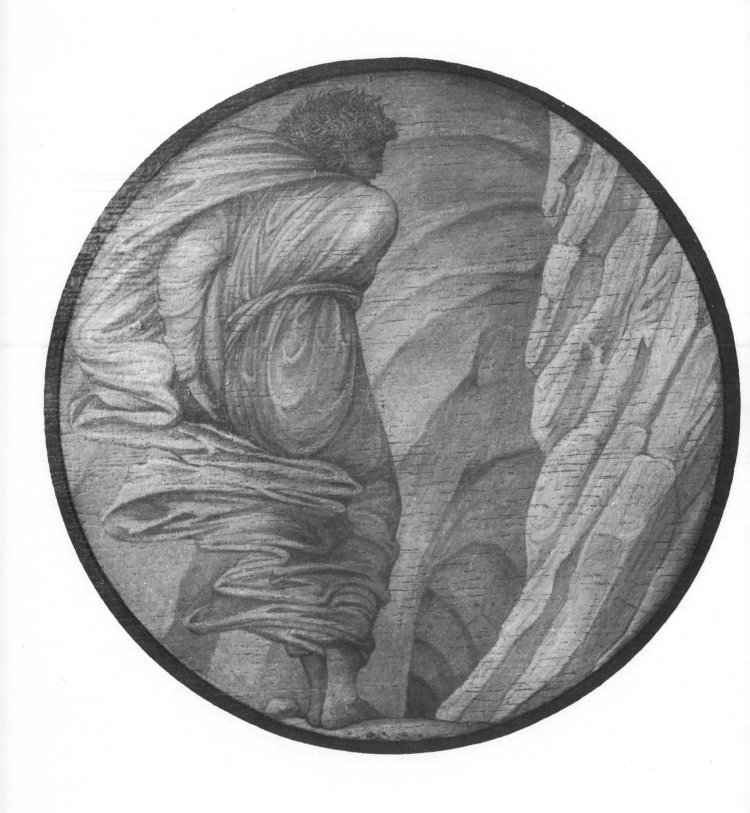

Orpheus: The Gate of Hell. (Orpheus sets out to bring Eurydice back from Hades.)

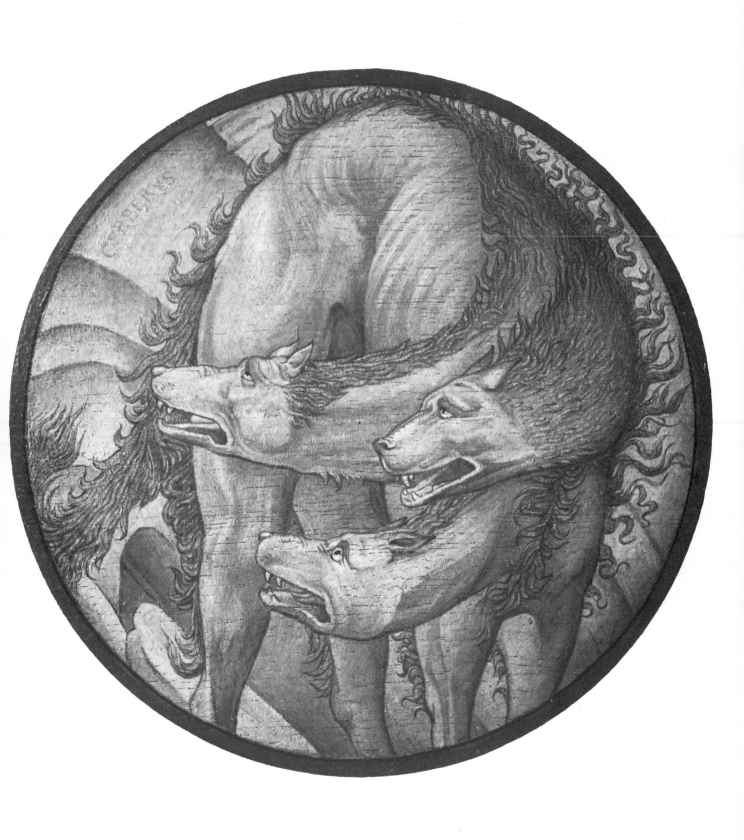

Orpheus: The Door Keeper. (The three-headed dog Cerberus.) 11

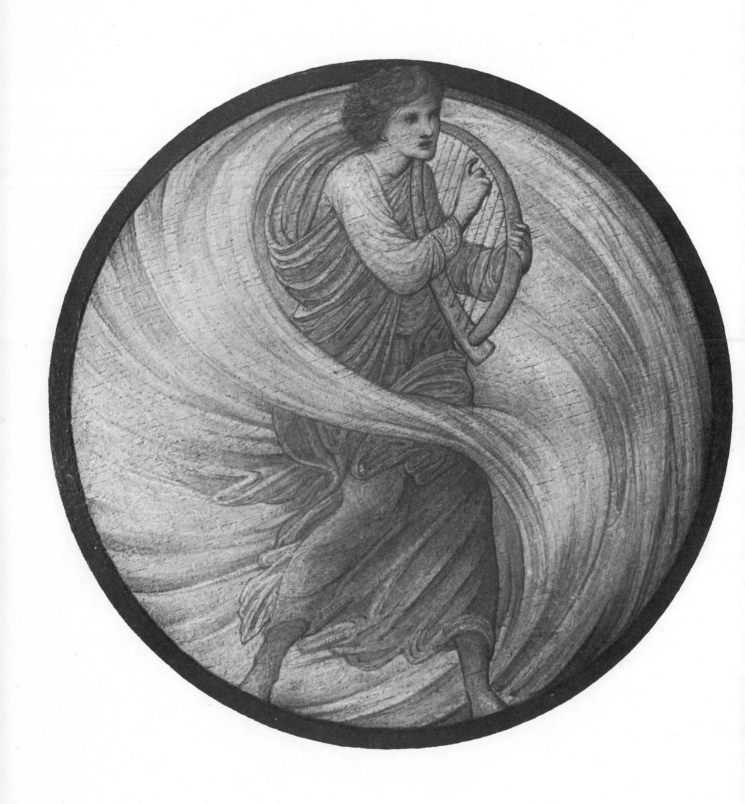

Orpheus: Across the Flames I.

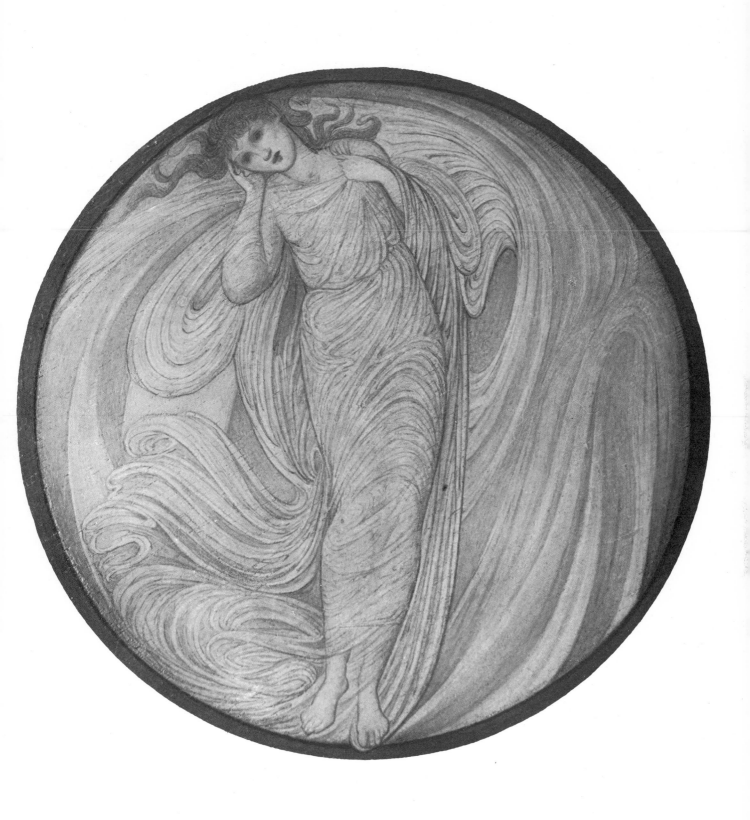

Orpheus: Across the Flames II.

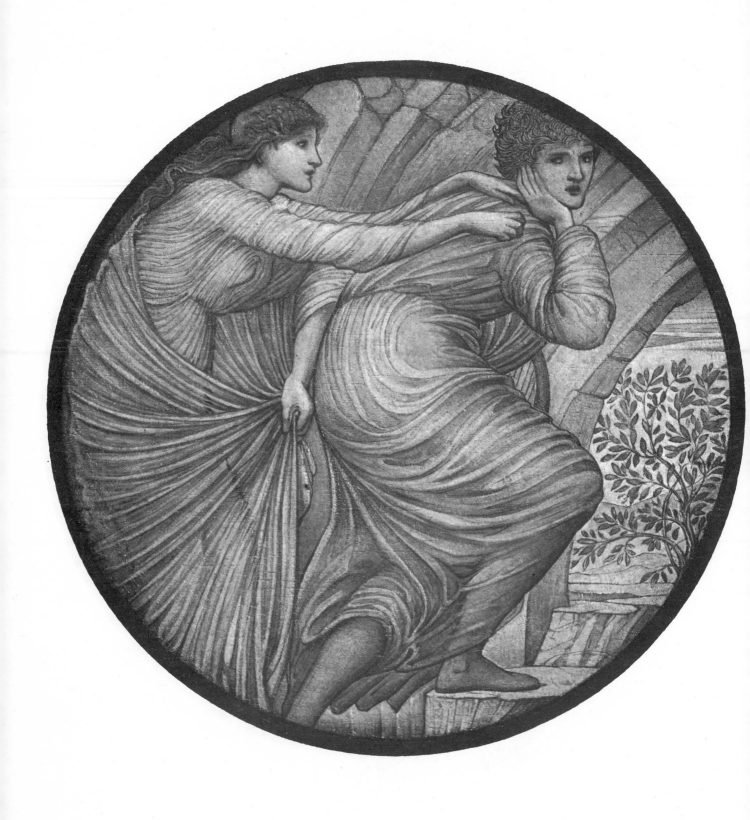

Orpheus: The Regained Lost I. (Eurydice has been allowed to live again if Orpheus does not look back at her on the way out of Hades.)

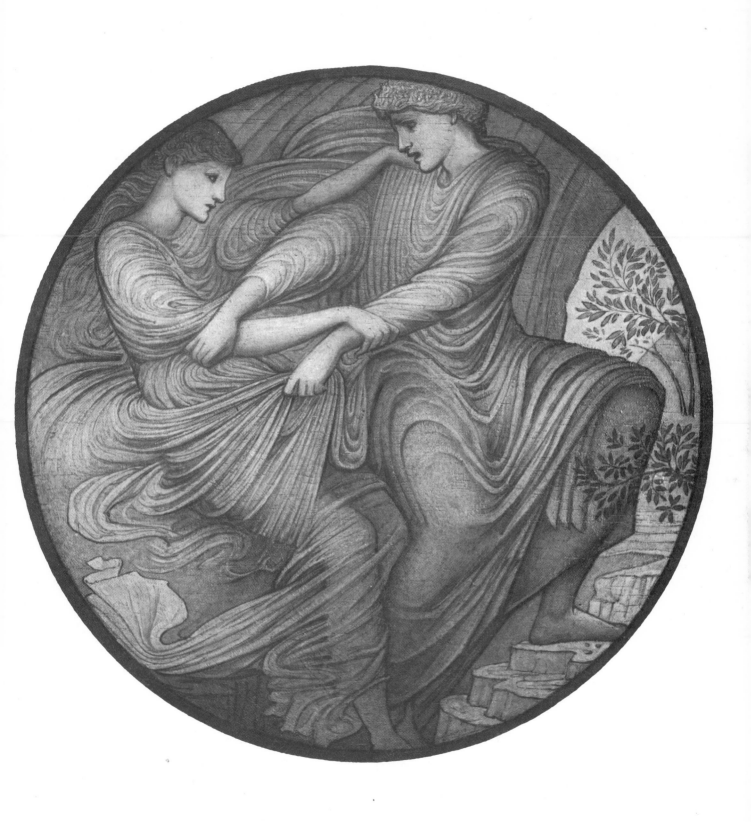

Orpheus: The Regained Lost II. (In his eagerness, Orpheus looks back.)



15

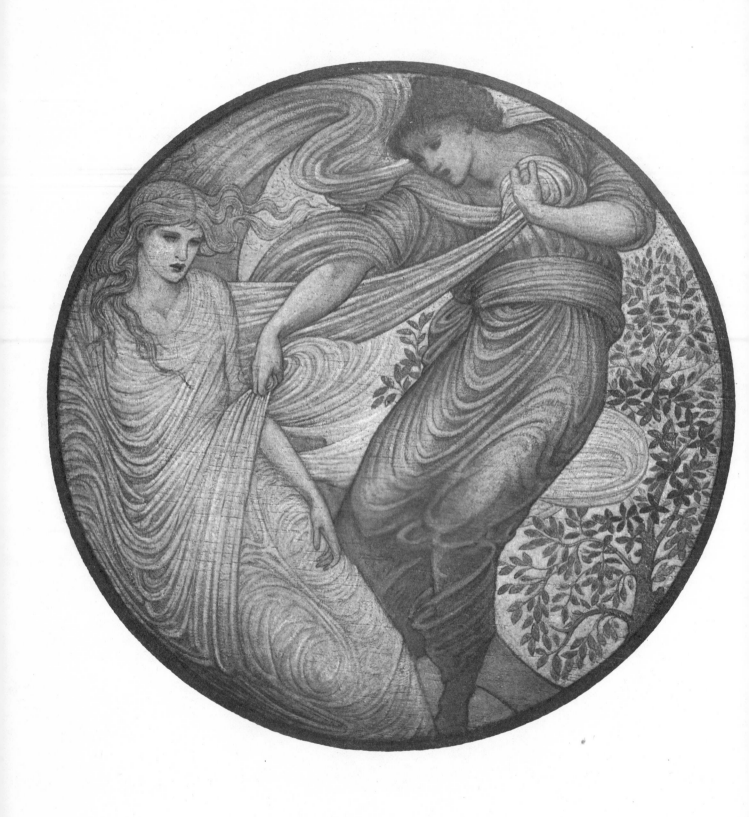

16 *Orpheus:* The Regained Lost III. (Eurydice is now totally lost.)

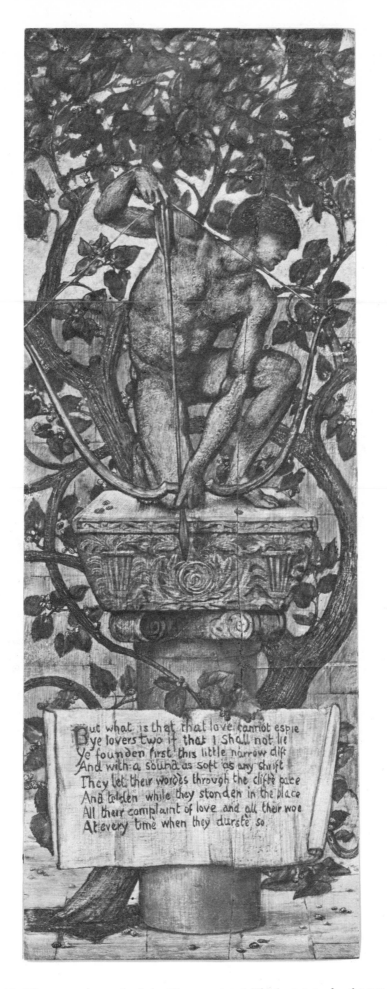

But what is that that love cannot espie
Ye lovers two if that I shall not lie
Ye founden first this little narrow clift
And with a sound as soft as any shrift
They let their wordes through the cliffe pace
And tolden while they stonden in the place
All their complaint of love and all their woe
At every time when they durste so.

Cupid. The central panel of the *Pyramus and Thisbe* triptych of 1872–6.

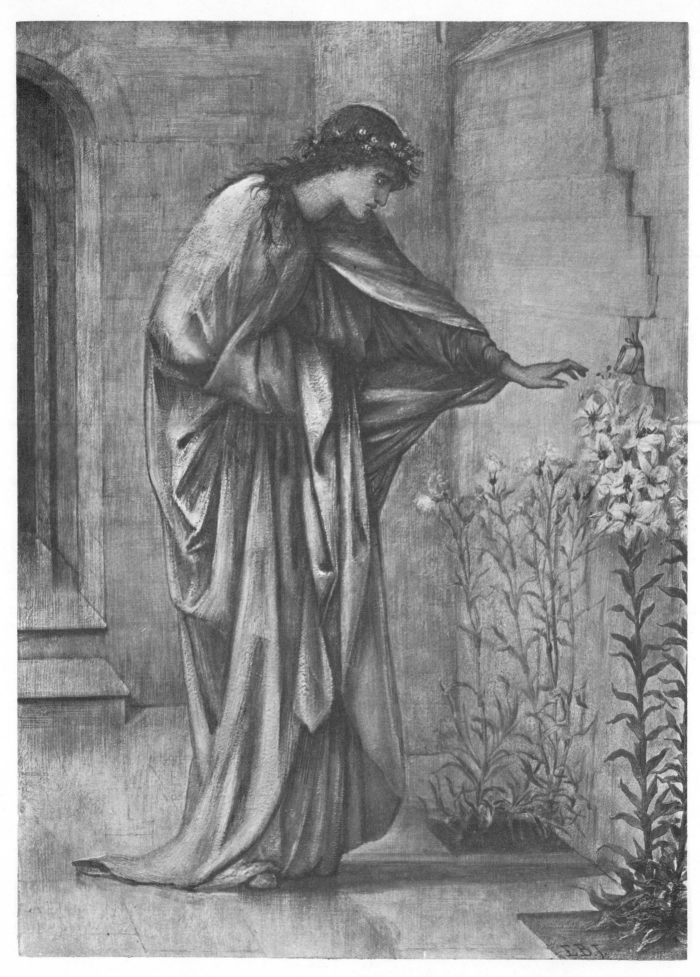

18 *Pyramus and Thisbe:* Thisbe receives a message through the cleft in the wall.

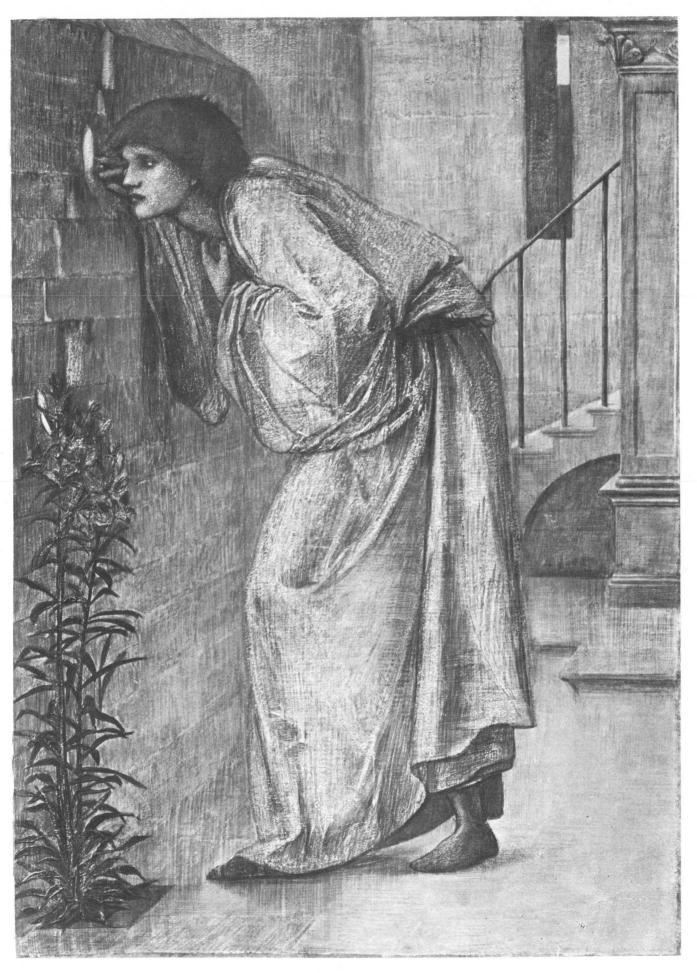

Pyramus and Thisbe: Pyramus at the wall.

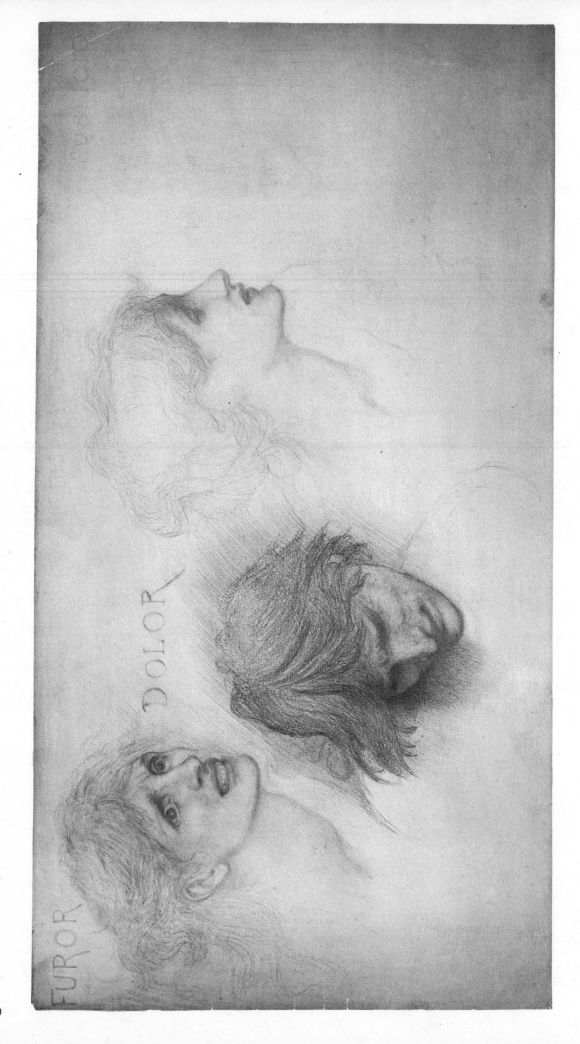

Second study for *The Mask of Cupid*. 1871. The characters shown—Fury, Griefe, Dissemblaunce and Suspect—appear in the episode of Cupid's masque in Spenser's *Faerie Queene*.

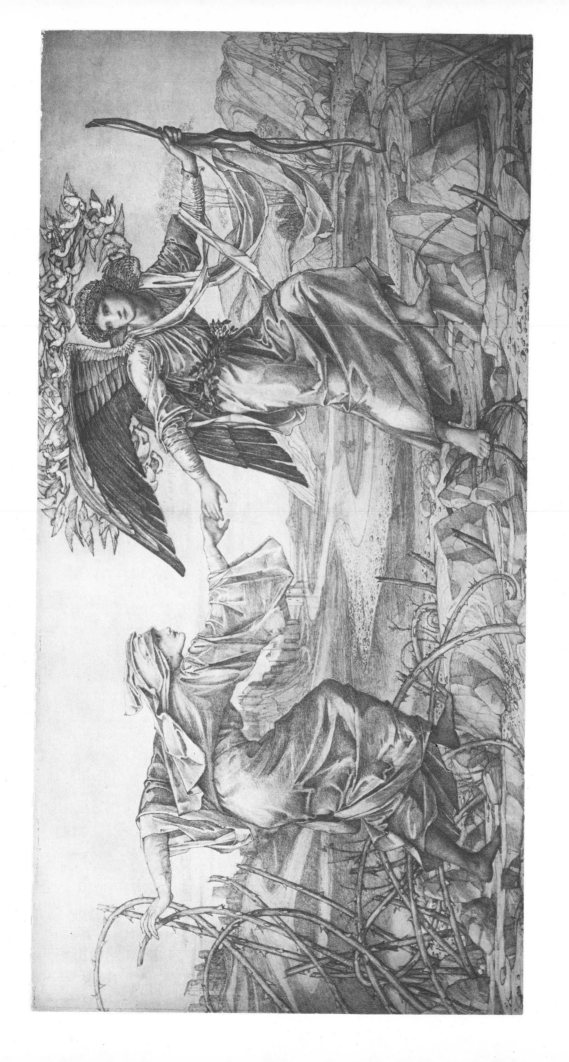

The Pilgrim of Love (or, Love Leading the Pilgrim). 1877. This subject, based on the *Romaunt of the Rose*, was completed as an oil twenty years later, in 1897.

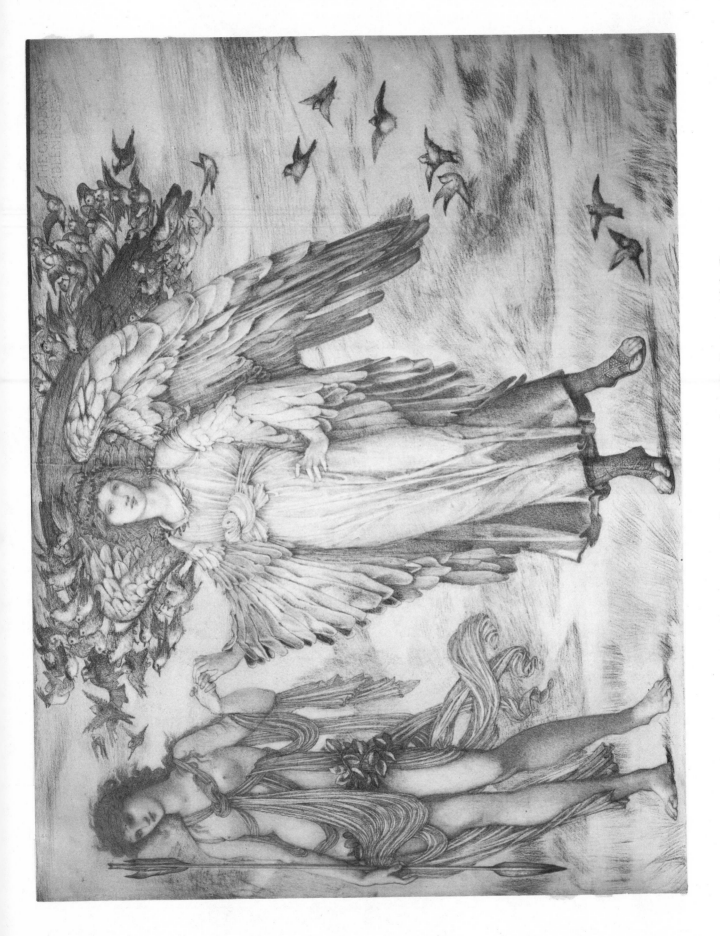

Love and Beauty. Ca. 1874. Allegorical figures from *The Romaunt of the Rose.*

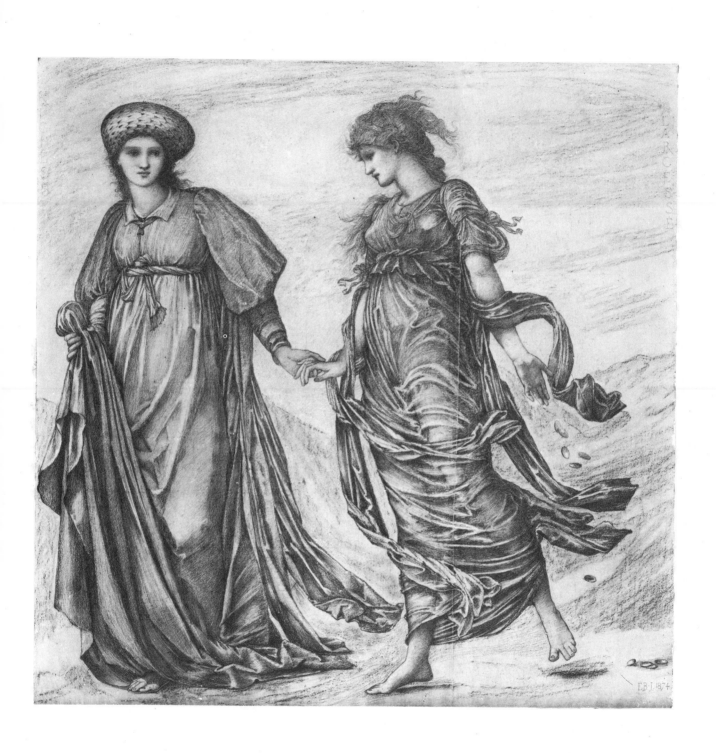

Wealth and Charity. 1874. Allegorical figures from *The Romaunt of the Rose.*

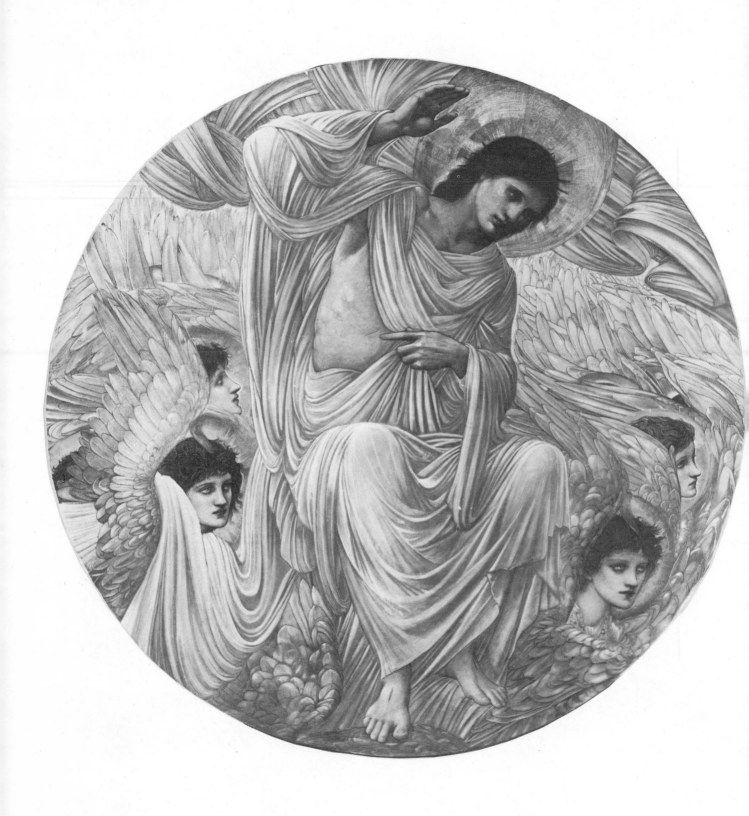

Dies Domini. 1880. (The Last Judgment.)

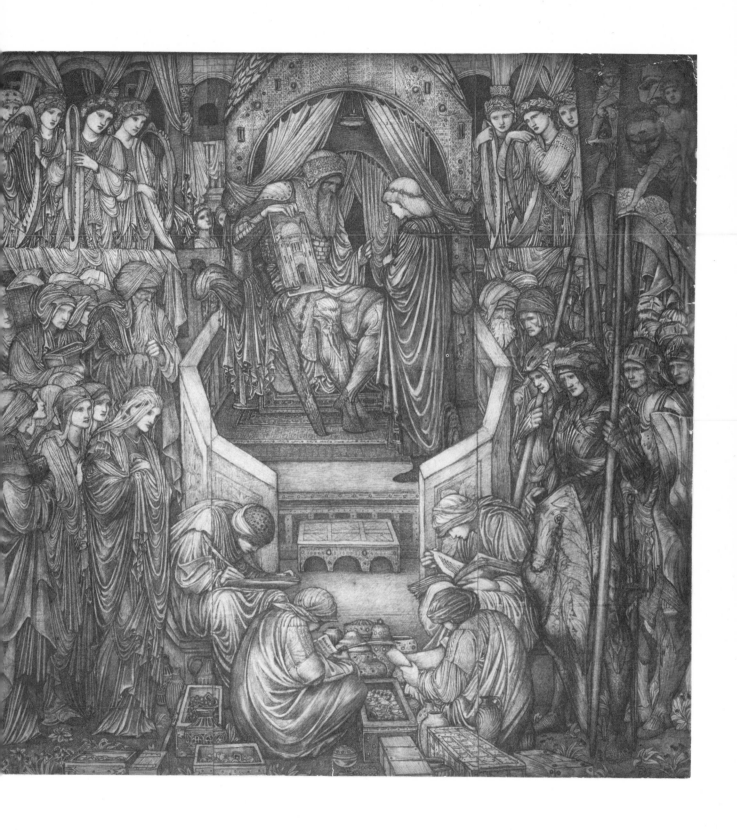

Building the Temple. 1888. Design for a stained-glass window in Trinity Church, Boston. (David shows Solomon the drawing of the projected Temple in Jerusalem.)

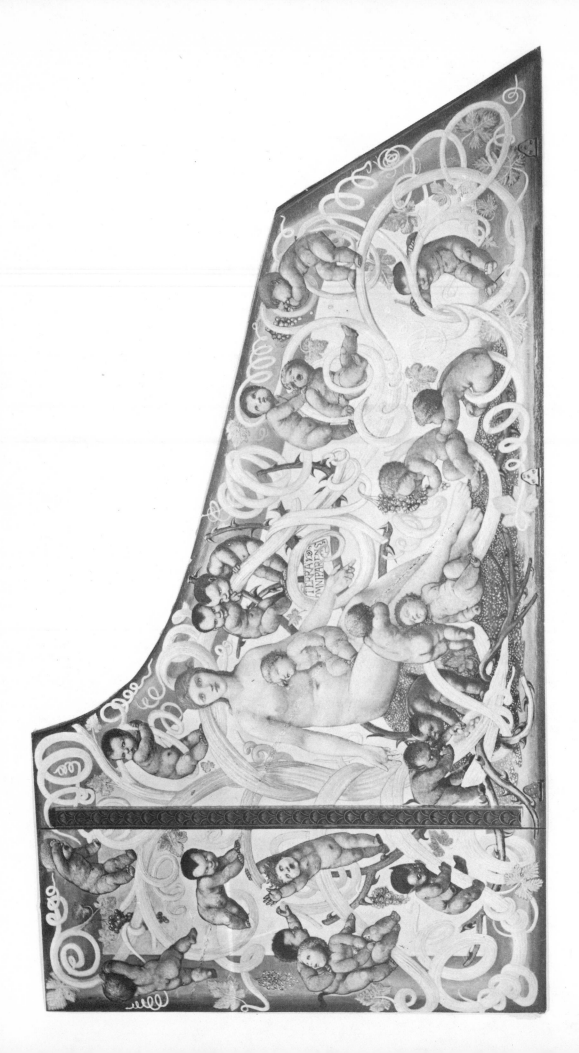

Painted piano lid: "Earth, the Universal Mother."

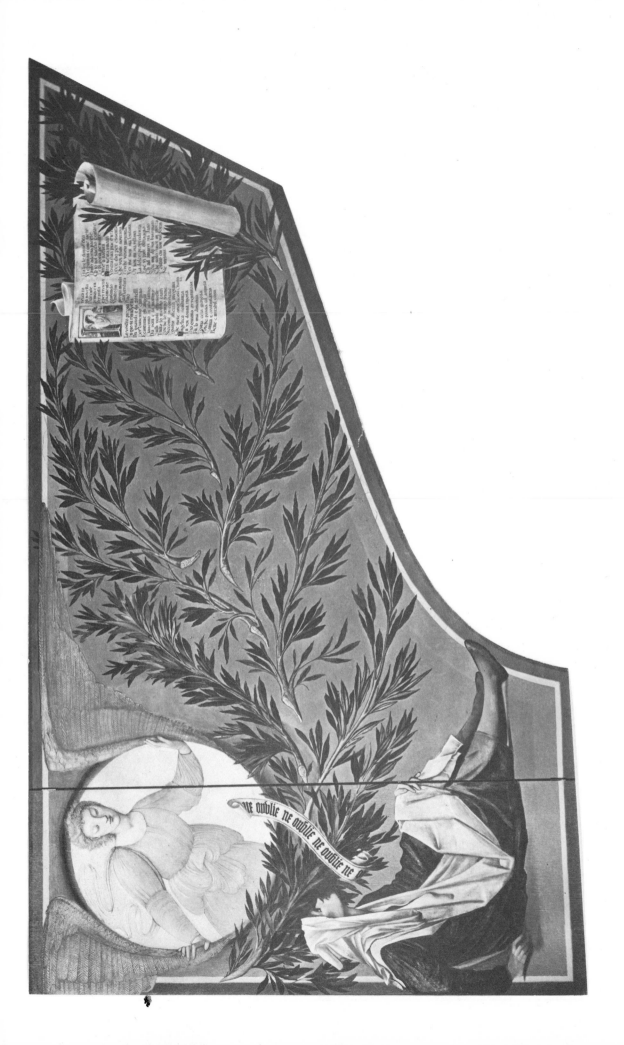

Painted piano lid: On the ribbon: "Forget not." The manuscript page contains a thirteenth-century Italian work of the *dolce stil nuovo* school of poetry.

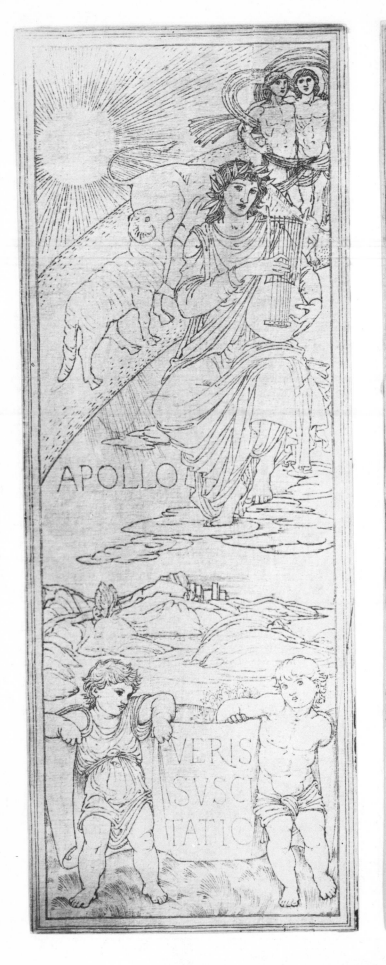

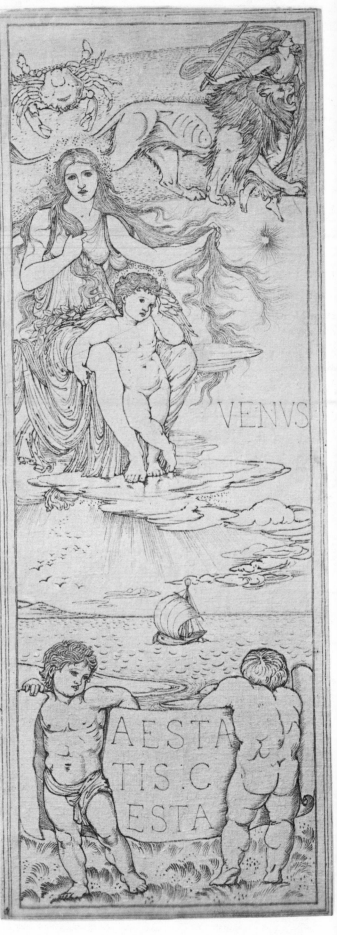

Seasons series, with the appropriate deities and zodiacal signs. LEFT: Spring's Arousal. RIGHT: Summer's Activities.

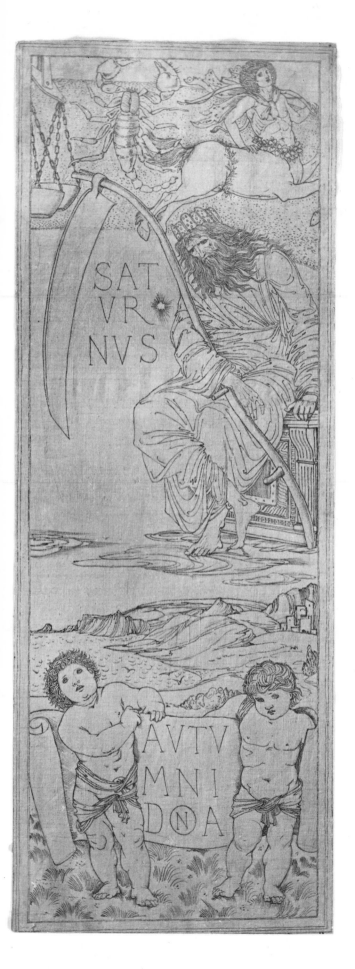

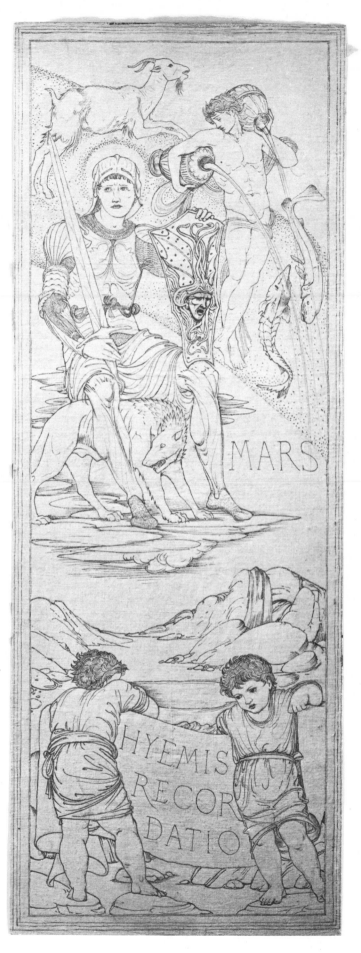

Seasons series. LEFT: Autumn's Gifts. RIGHT: Winter's Remembrance.

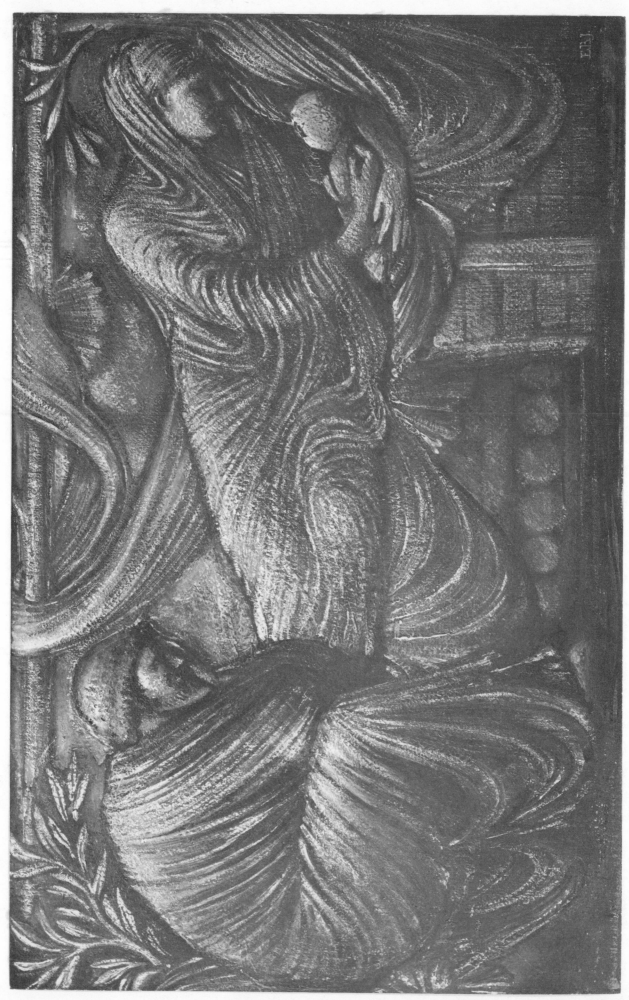

The Nativity. Design for a bronze relief

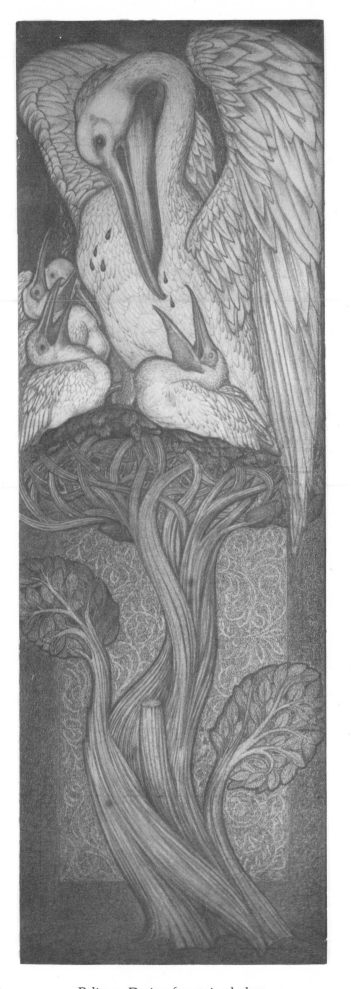

Pelican. Design for stained glass.

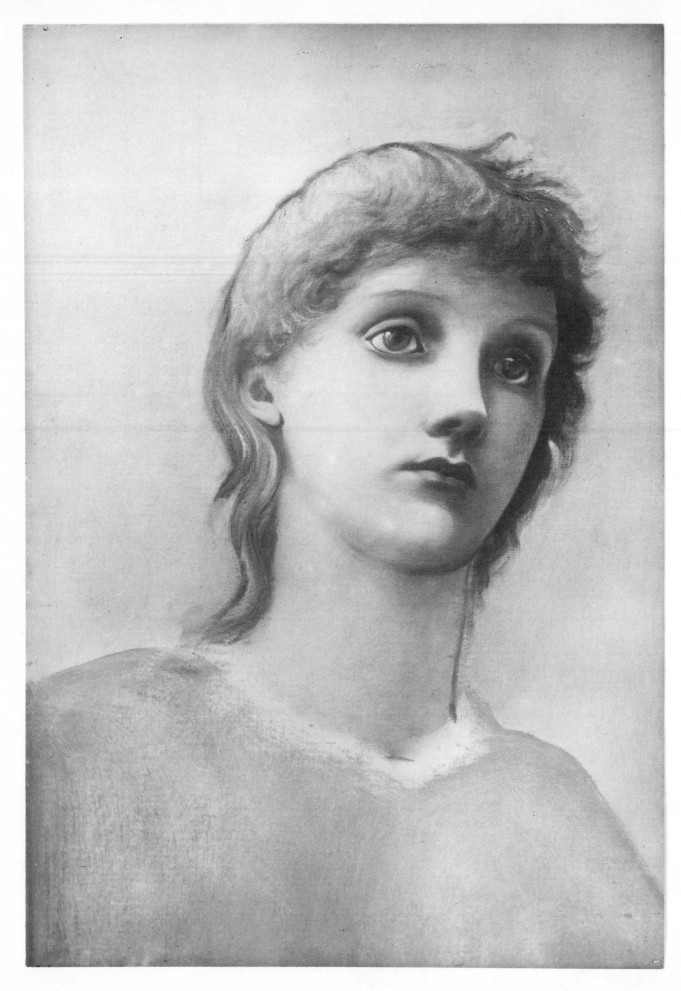

Study head.

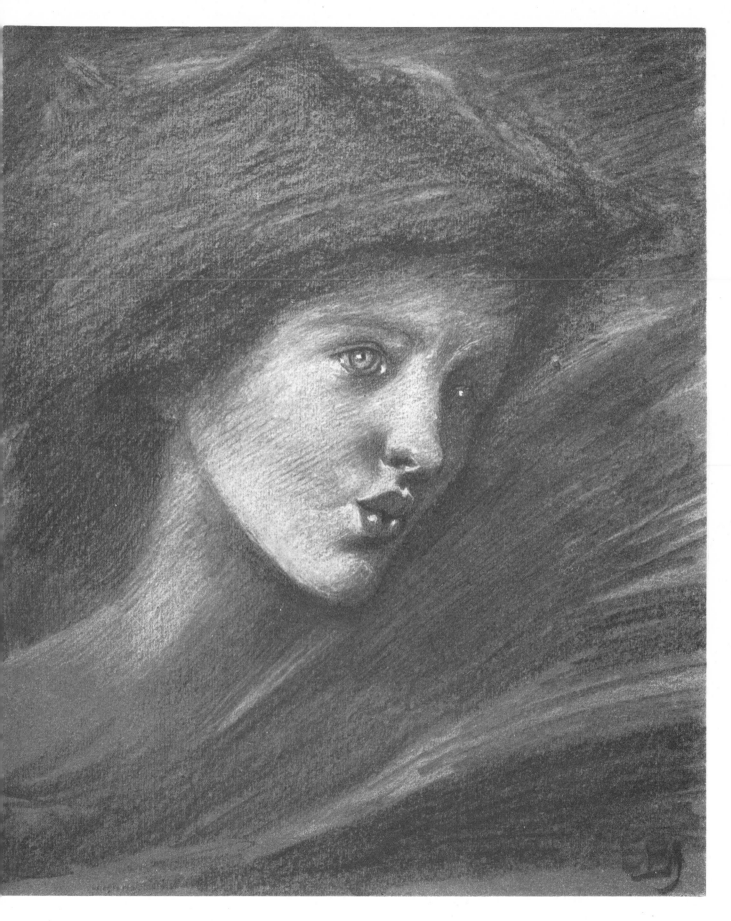

Study for one of the Zephyrs in the 1891 painting *Sponsa de Libano* (the bride
from Lebanon in Solomon's *Song of Songs*). This painting was a further
development of "The Winds," one of a series of four *Song of Solomon*
drawings done in 1876.

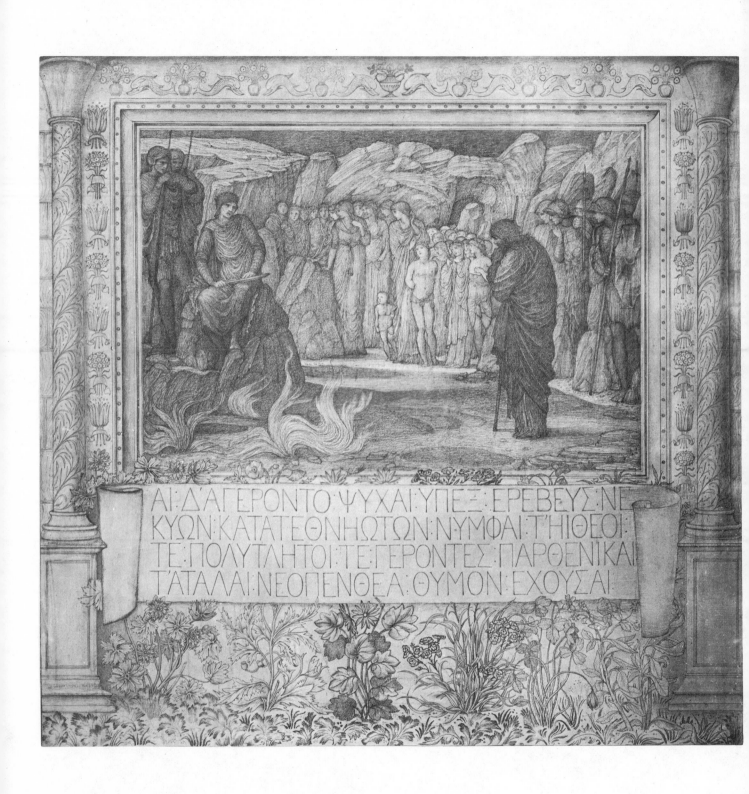

Ulysses in Hades. The quotation from the *Odyssey* describes the souls of the
people, both old and young, who flock around the hero in Hades.

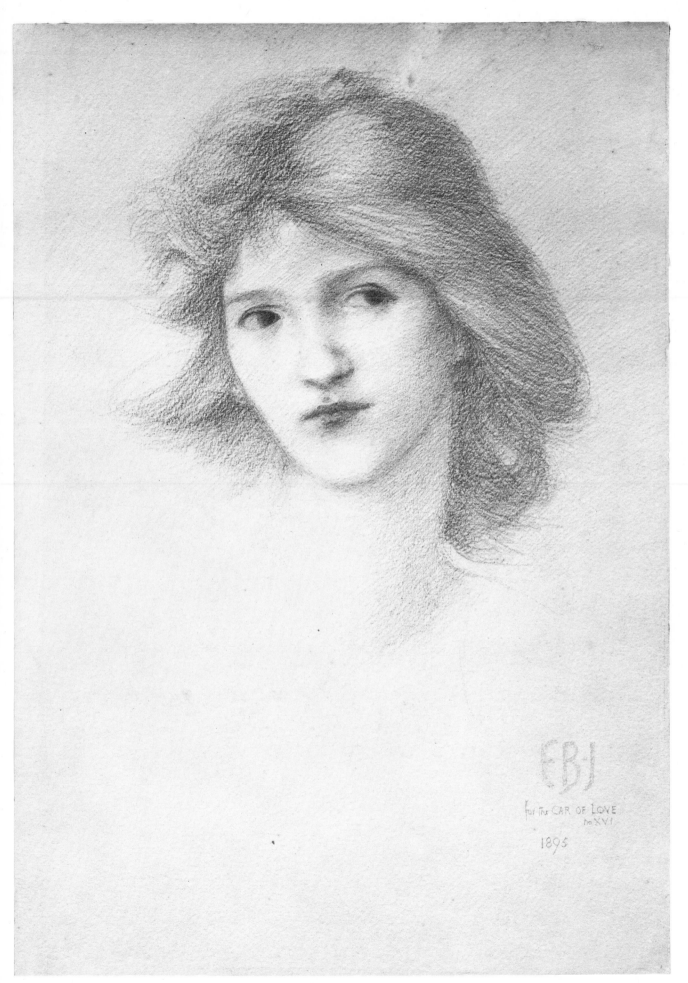

Head. 1895. Study for *The Car of Love*.

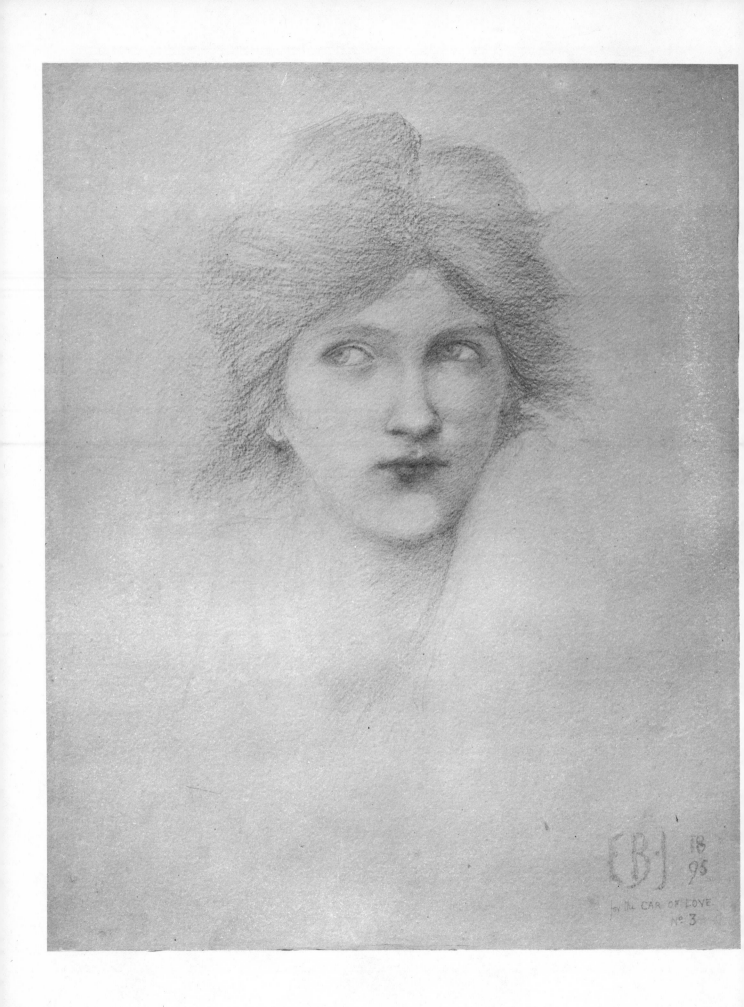

Head. 1895. Study for *The Car of Love*.

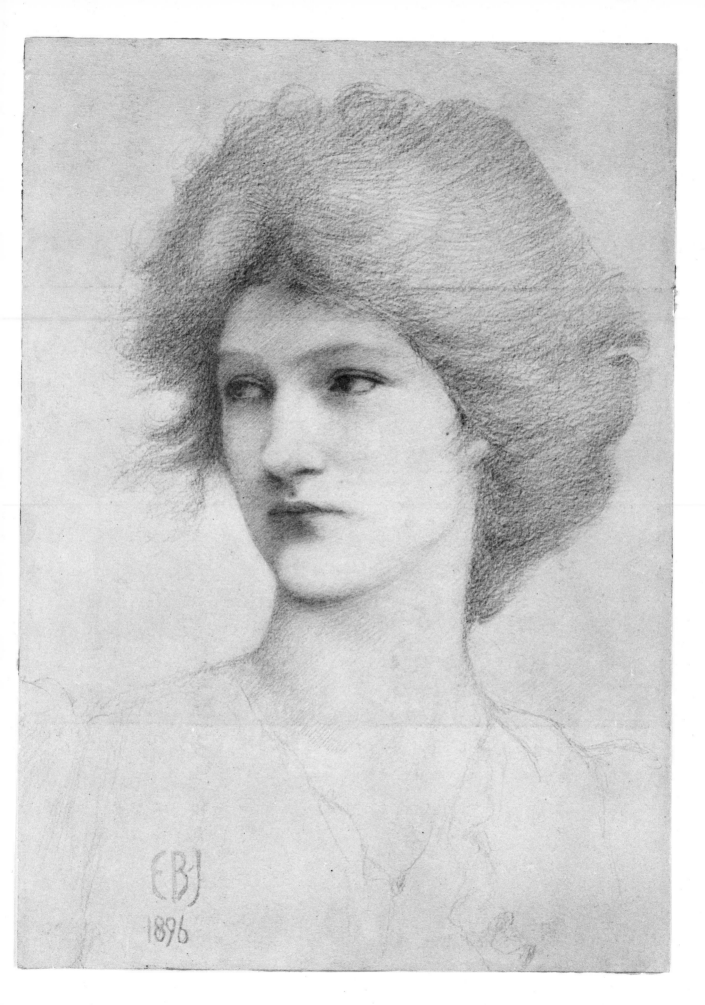

Head. 1896.

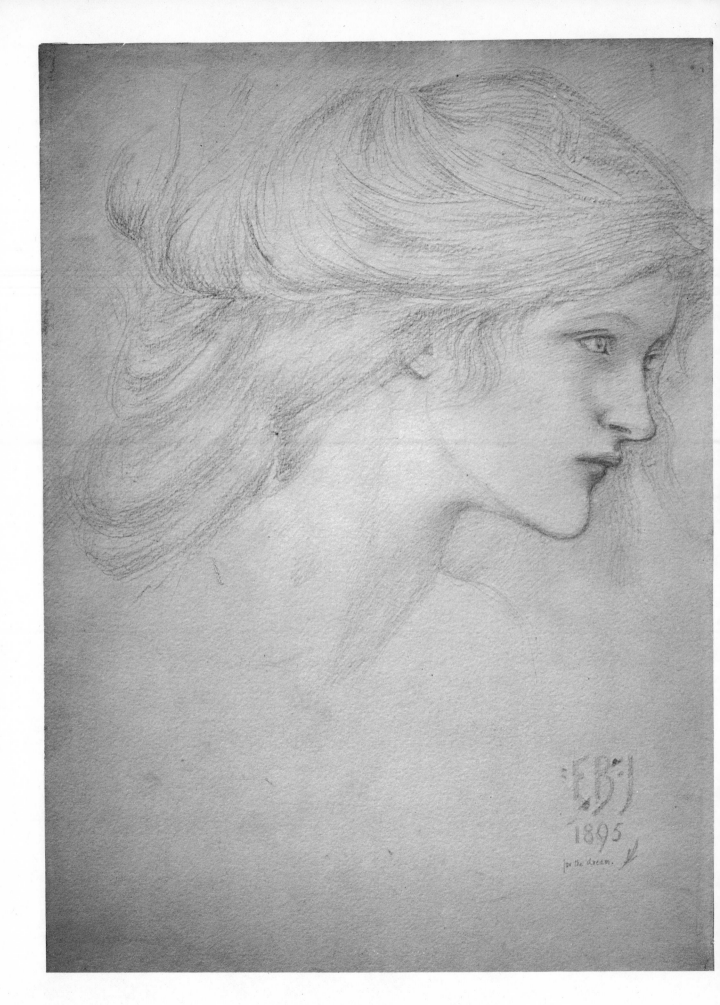

Head. 1895. Study for *The Dream*.

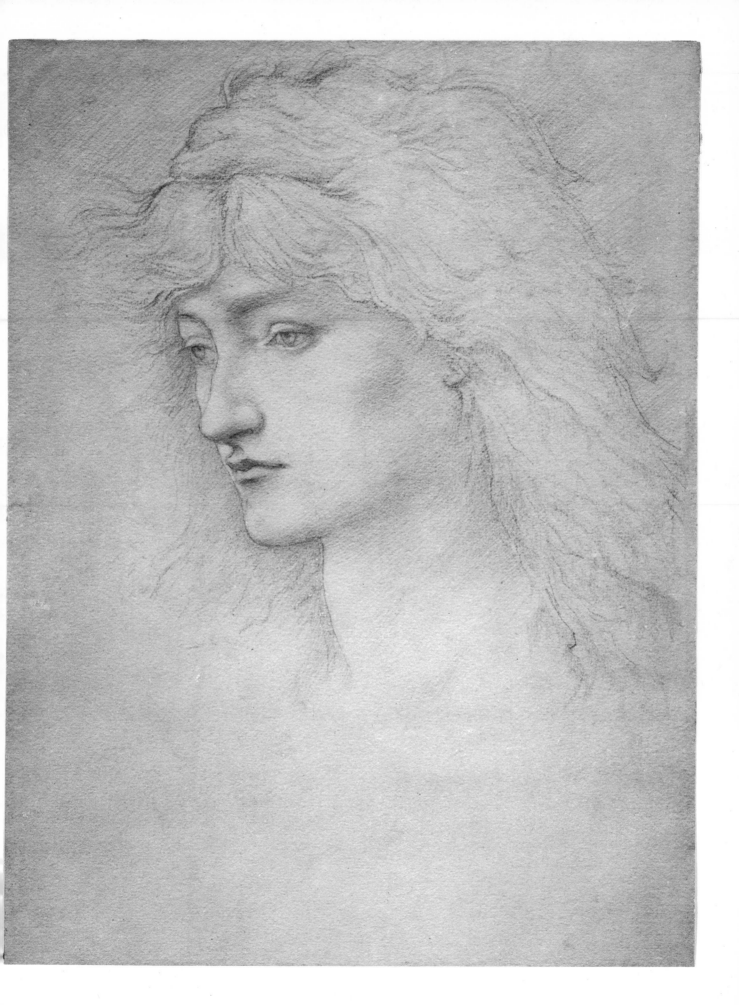

Head. Ca. 1895.

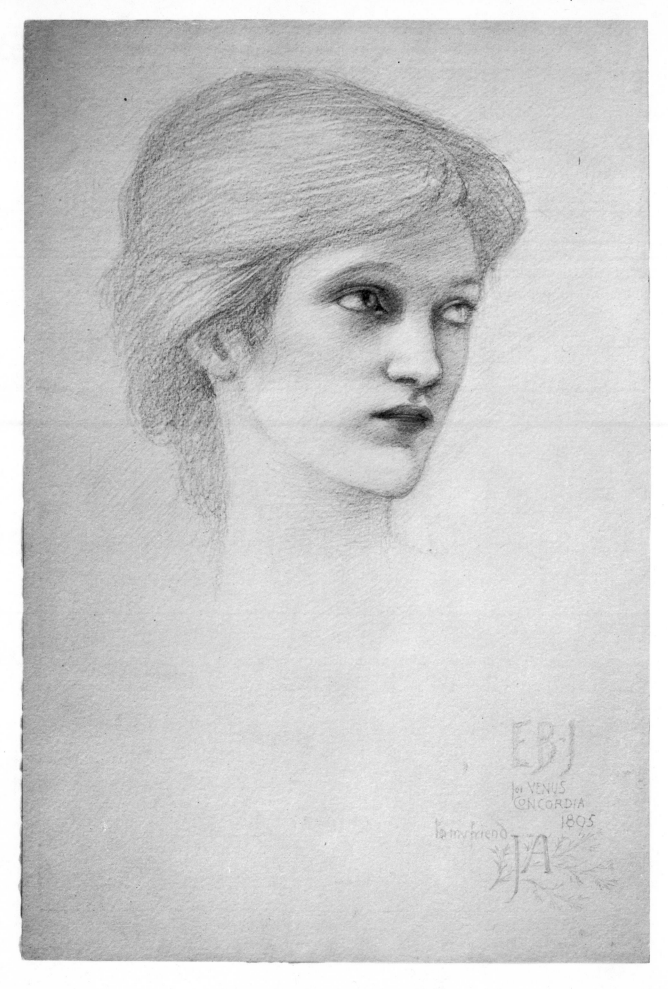

Head. 1895. Study for *Venus Concordia*.

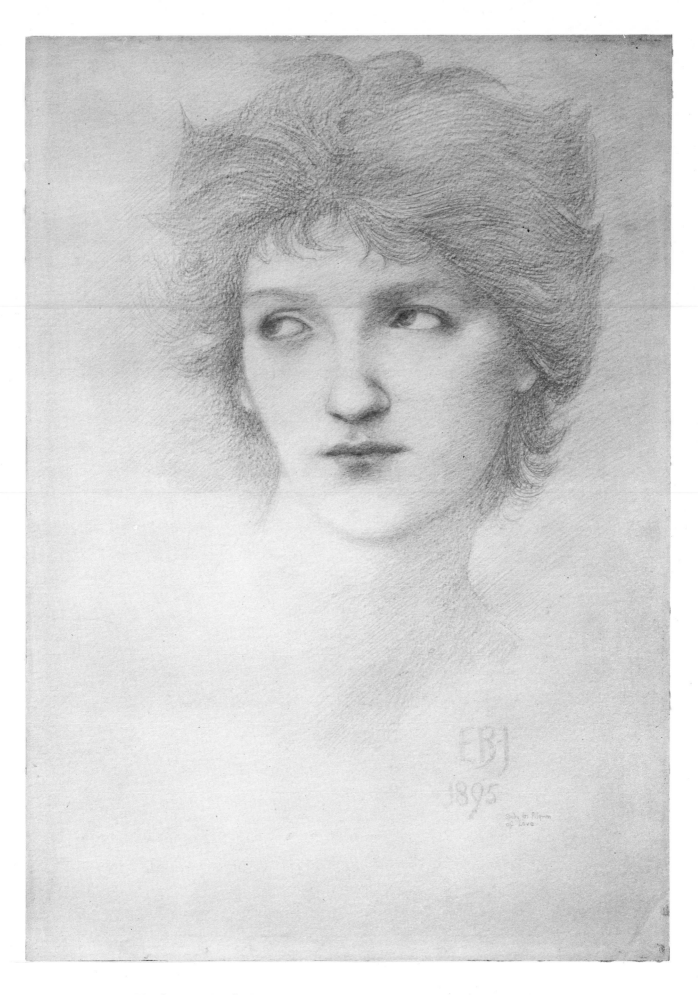

Head. 1895. Study for *The Pilgrim of Love* (painting completed 1897).

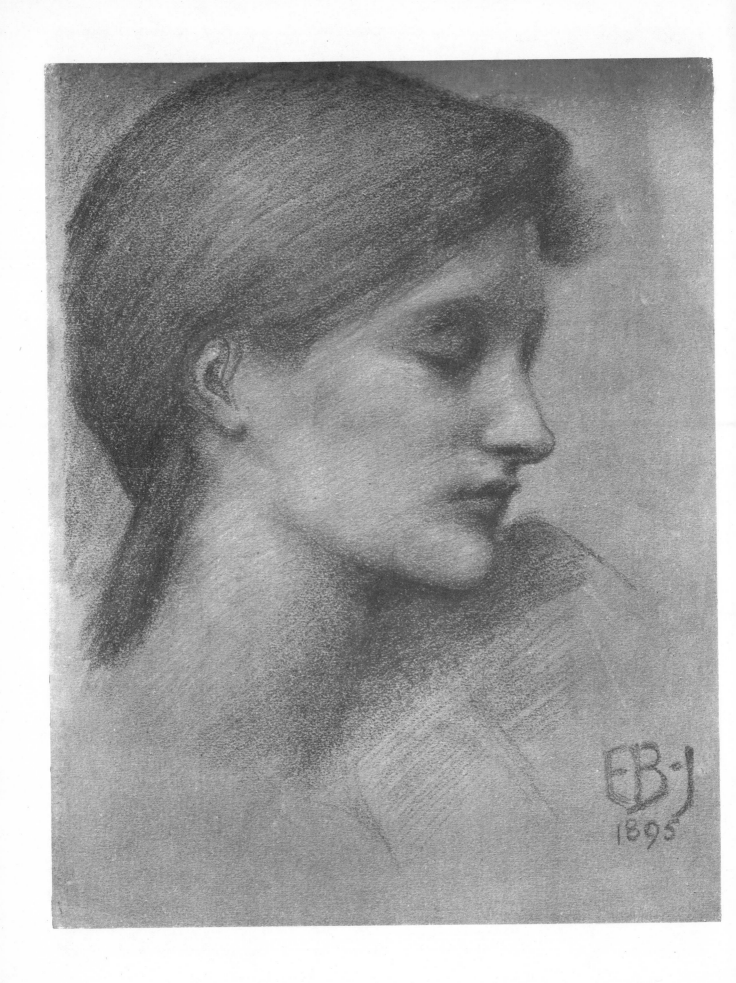

Head. 1895.

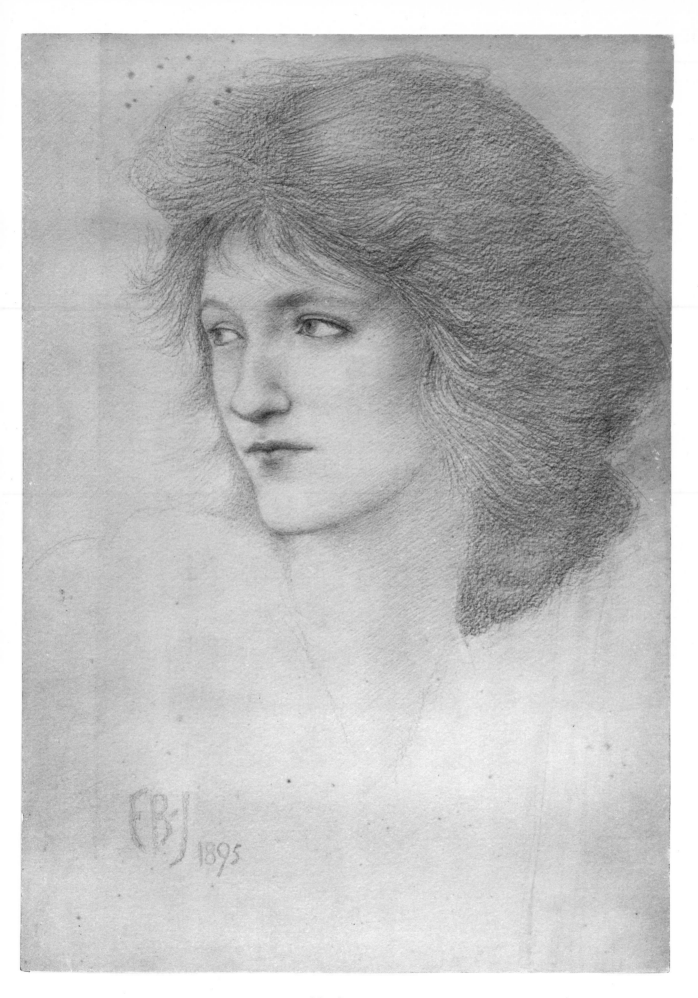

Head. 1895.